Ceramic Painter's Pattern Book

Edited by Rachel Byass

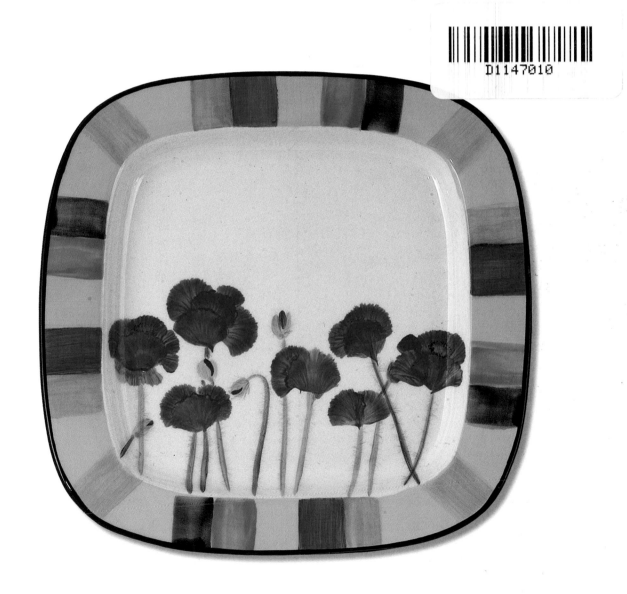

SEARCH PRESS

First published in Great Britain 2007 by

Search Press Limited
Wellwood
North Farm Road
Tunbridge Wells
Kent TN2 3DR

Text copyright © Search Press 2007
Photographs by Steve Crispe
Photographs and design copyright © Search Press Ltd 2007

ISBN 10: 1-84448-201-4
ISBN 13: 978-1-84448-201-6

The *Ceramic Painter's Handbook* is a compendium volume of illustrations taken from the Design Source Books: *Angel & Fairy Designs, Art Deco Designs, Art Nouveau Borders & Motifs, Art Nouveau Designs, Chinese Designs, Christmas Designs, Classic Border Designs, Decorative Initials, Egyptian Designs, Floral Borders & Motifs, Flower Designs, Folk Art Designs, Garden Flower Designs, Halloween Designs, Manga Characters, Medieval Designs, Mythical Creatures, Native American Designs, Oriental Flower Designs, Roman Designs, Traditional Indian Designs, Traditional Japanese Designs, Victorian Designs, Wedding Designs.*

Publisher's note
The step-by-step photographs in this book feature Rachel Byass demonstrating her ceramic painting techniques. No models have been used.

Suppliers

If you have any difficulties obtaining any of the materials and equipment mentioned in this book, please visit the Search Press website for details: www.searchpress.com; or visit the Country Love website: www.countryloveceramics.com; or contact Rachel Byass: www.firedartdesigns.co.uk.

Page 1
Poppy Tray
Design: see page 26

This colourful tray would complement any supper table.

The design is transferred using the carbon paper method (see page 7).

One-stroke paints are used. The colours are placed on a tile and thinned with a little water.

A No. 6 round sable brush is used to paint the poppies.

The brush is loaded with light red and tipped in dark red. To complete a stroke, the brush is laid on the bisque surface and the handle twisted back and forth until it opens up like a grass skirt. The back of the brush is lifted and it is pushed forward and pulled back to make a lovely rippled petal with a wavy edge. The other petals are painted in the same way using a little orange at intervals to vary the shades of colour.

A No.1 liner brush is used for the stems. This is loaded with two shades of green and pulled up to the flower heads.

The buds are painted with a No. 3 round sable brush which is loaded with red. The tip of the brush is placed on to the bisque, pressed a little and then pulled forward slightly, with pressure released as the brush moves so the colour comes to a point. The liner brush is used, loaded with green, to pull two more strokes in the same way.

The poppy centres are painted with different shades of green, using a small sponge which is pounced up and down in the middle of the flower.

To complete the plate, a banding sponge is loaded with different colours in turn which are pulled over the lip of the plate. When dry, the edge of the plate is banded with black.

The plate is put in the kiln and the colours are fired into the plate before it is glazed with a clear glaze and refired.

Contents

 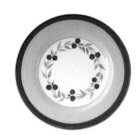 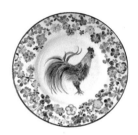

Bamboo Goblet and Plate

Design: see page 45

This is a great little number for a bachelor pad. The set is completed using glaze-based underglaze colours and outlined in one-stroke underglaze.

The goblet is roll-glazed on the inside. This is done by thinning black underglaze fifty per cent with water, pouring it into the goblet and rolling it round four times before tipping it out.

The back of the plate is painted three times with a No. 8 fan brush and full-strength black underglaze, as are the top and bottom of the goblet.

Dark yellow underglaze is thinned fifty per cent with water and one coat is painted on to the front of the plate and the sides of the goblet, using a No. 8 fan brush.

When the colours are dry, the design is transferred on to the two items using the tissue paper method (see page 8).

The bamboo stem is achieved with a No. 6 round brush. This is loaded with dark caramel and a little darker brown is placed on the side of the brush which is then

pulled up from the bottom of each design. A wavy action is used which creates varying shades as the two colours blend.

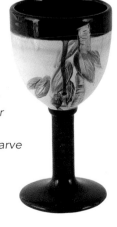

The leaves are painted in with No. 6 and No. 3 brushes, larger and smaller respectively. The brushes are loaded with light green and side-loaded with dark green. A press, pull and lift action (see page 9) is used to lay in each leaf. Brown is added to some of the leaves.

Black one-stroke is thinned seventy per cent colour, thirty per cent water, and the two designs are outlined with a No. 1 liner brush. Veins are then added to the leaves.

To highlight the stems and leaves, a sgraffito tool is used to carve the colour back to the bisque, revealing the white surface.

To create a perfect edge on the plate, black underglaze is banded on with a banding sponge.

When dry, the goblet and plate are clear-glazed and fired.

Introduction

This book is brimming over with fun ideas and decorative designs to suit all occasions. With the ceramic painter in mind, the patterns, motifs and illustrations have been specially selected to be used on a range of bisque ware, including plates, bowls, mugs, vases, frames, tiles, trays and more. Bisque is sold on the internet, in the hugely popular ceramic cafés that are springing up everywhere; it is also available in craft stores.

The finished items in this book have been coloured with paints that require firing, so they will all need to go through the firing process at least once. Small, relatively inexpensive kilns can be purchased if you are interested in painting more than a few objects. Alternatively, ceramic cafés offer a daily firing service, along with their paint-your-own pottery facilities, or you may be able to organise the firing of your items with an adult education centre in your area or with a local potter.

You do not need artistic skills to make beautifully decorated objects. The first section of this book includes an easy guide to the materials needed, plus a comprehensive step-by-step introduction to the basic techniques. Materials have been kept to a minimum to make it more affordable for you to embark on a very exciting and rewarding pastime, whether you are making a functional piece for your home or gifts for family and friends.

As your skills grow, you will start to gain in confidence and soon discover that experimenting with colours and brush strokes is all part of the fun. Hopefully, you will feel encouraged to visit your local ceramic café, where you can pick a pot and paint with others who love working with ceramics; or you could invite a few friends around for an enjoyable painting session. Even though I have been in the industry for over twenty years, I still get a buzz when the kiln is opened and I see the final results. Colours are transformed by the firing process and it is a truly magical experience. Whatever your skill levels, I hope you enjoy this book and I wish you happy painting.

Daisy Planter

Design: see page 16

This is a simple banded planter embellished with brushstrokes.

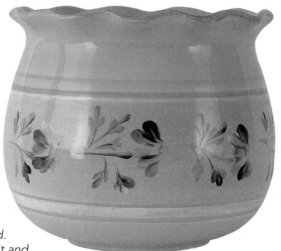

Glaze based underglaze paints are used on the background. When applying the daisy design, a No. 3 round brush is dipped in white raised glaze and a little colour is added to the tip.

The background is applied using a banding wheel. After thinning pale blue, thirty per cent water to seventy per cent colour, the paint is banded on to the planter with a No. 8 fan brush. Thinned pink, with the same dilution, is then banded on to the centre of the planter. The finer bands are added with a No. 3 round sable brush loaded with slightly diluted jade.

When the colours are dry, the design is transferred using the tissue method (see page 8).

The daisies and leaves are added with the No. 3 round sable brush. To make the daisies opaque, a slightly raised glaze is used. The white paint is squeezed on to a tile and the brush pulled through it and then tipped in purple and pink one-stroke paint. The press, pull and lift stroke is used to make five petals (see page 9), which are pulled from the outside edges in.

The No. 1 liner brush, loaded with green one-stroke paint, is used to pull in all the stems. The No. 3 round sable brush is double-loaded with two shades of green and the same press, pull and lift stroke is used to add the leaves.

To complete the flowers, a cotton wool bud is used to stipple two shades of green into the centre of the daisies.

The small buds are applied with the No. 3 brush, with a single press, pull and lift stroke.

When dry, the planter is dipped in clear gloss glaze and fired.

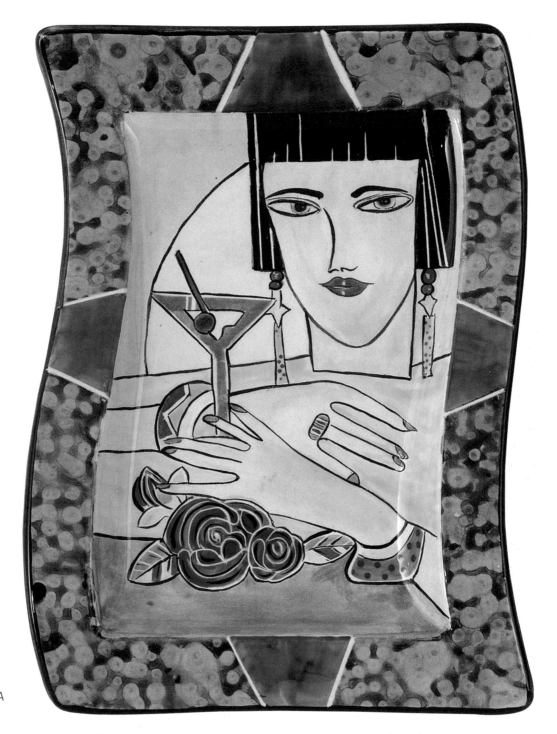

Art Deco Dish

Design: see page 62

This dish is painted with glaze-based underglaze paints and detailed with one-stroke underglaze. A sgraffito tool is used to carve back the colour to the white of the bisque. The unusual mottling is created using Isapropanol. The design is transferred using the tissue paper method (see page 8).

All the colours are blocked in three times using No. 2 and No. 4 round sable brushes.

When the border is dry, purple one-stroke is thinned, seventy per cent water to thirty per cent colour. Areas of no more than 2.5cm (1in) are puddled on to the light purple border with the No. 3 brush and Isapropanol is dripped on to these areas while the paint is still wet. This is done because if the paint is dry the Isapropanol will not disperse the colour and you will not achieve the mottled effect.

A ruler is laid across the still-damp edges of the blue areas and border lines are carved against the straight edge, with a sgraffito tool, to reveal the white bisque.

Highlights are then added to areas of the design and the hair with the sgraffito tool.

The main design is outlined and some areas darkened with diluted black one-stroke loaded on to a 10/0 liner brush

Finally, a black border is applied using a banding sponge.

When completely dry, the dish is clear-glazed and fired.

Materials

All the materials for painting designs on to bisque ware are readily available, either from the internet, ceramic cafés, or art and craft shops.

Bisque ware

Bisque is liquid clay, or slip. It is poured into a plaster mould and when up to ¼in (6mm) has set, it is poured out, leaving the residue in the mould. When this is leather-hard and can maintain its own weight and shape, it is taken out of the mould. This is known as greenware and it is left to dry; it is then cleaned and this is known as 'fettling'. After firing in the kiln it becomes bisque ware.

Paints

Two types of paint are used in the vase project and they are both underglaze colours for bisque surfaces.

One-stroke paints are made up of pure pigment and water; they have no glaze content, are non-toxic and food-safe. They are best used for fine detail. One brushstroke is all that is necessary for vibrant colour, hence the name. The colours are translucent and are therefore not suitable for solid coverage. Also, they stain the bisque and therefore have to be applied carefully.

Glaze-based underglaze paints are also used and one, two or three coats can be applied to the bisque; depending on the amount of colour applied, the value will vary from transparent to semi-transparent and opaque. These paints easily wash off if you make mistakes, so they are very popular in ceramic cafés

Brushes

Brushes used for ceramic painting should be used solely for this purpose and it is advisable always to buy the best you can afford. The most commonly used brushes are:
Goat fan brush, No. 8, used for banding and glazing.
Sable liner brush, Nos. 1 and 10/0, used for outlining and painting detail.
Round sable brush, Nos. 2, 3, 4 and 6, used for general colouring in and brushwork.
Round sable brush, No. 12 used for larger areas and brushwork.
Squirrel brush, soft No. 2. This tapers off to a fine point and is often referred to as a sumi brush.
Goat hair brush, soft 13mm (½in), used to apply soft background colour.
Angled square shader, 10mm (³/₈in) and 13mm (½in), used for all areas of colour, solid coverage and brushwork.

Piping paste

This clay-based product is normally available in black or white and it comes in pint bottles. It is a matt product and is used to create raised designs and embellishments on top of, or underneath glaze colour. It is often used to make a piped line known as tube lining.

Glazes

Glaze is used as a top coat. It is either matt or gloss clear. Matt glaze and clear gloss glaze are available as brush-on products and are easily applied. Clear gloss glaze is also available in a dip form and is normally used in ceramic cafés, so customers need not worry about glazing their items.
Raised glaze is also available in a range of colours and comes in small bottles fitted with piping nozzles. It is great for embellishing designs, adding lettering and it can be applied on top of, or underneath, an unfired glaze.

On glazes

On-glazes, such as gold, silver and Mother of Pearl, can be applied to your projects after they have been through the glaze firing process. An on-glaze is applied to a glazed surface and fired to a lower temperature to mature the finish.

Other equipment

You do not need much extra equipment, but it will help to have a selection of the following:

A **banding wheel** is a useful tool if you want to create fine bands of colour on a plate, or simply cover a pot in colour.

Banding sponges can be used with or without a banding wheel to band the outer rim of a plate.

Sea sponges can be used to make lovely lacy patterns on bisque if you gently pounce them on and off the surface with underglaze colour.

You will also need a **palette** for your paints and a glazed tile is useful as a surface for blending your colours when doing brushwork.

A **sgraffito tool** can be used to carve designs through applied colour back to the bisque.

Clay carbon paper is used for transferring designs on to the surface of the bisque. **Tissue paper** can also be used. It must be natural, acid-free and absorbent to allow a felt-tipped pen to penetrate through the tissue to the bisque.

Isapropanol is a liquid used for cleaning machinery. When used with underglaze colours it makes the paint disperse and creates a mottled effect.

You will also need **masking tape**, to secure the carbon or tissue paper to the bisque surface; **cotton wool buds** for stippling in colour; a permanent marker, a **ballpoint pen** and a **soft pencil** to transfer your designs;

Preparing surfaces

It is important that the bisque is clean before applying colour. With the tissue paper method (see page 8), the areas to be painted should be damp-sponged and allowed to dry before the design is transferred. With the carbon paper method (see below), the design should be transferred on to the bisque surface before damp sponging, or the outlines will fade away.

Transferring a design

There are a number of ways to transfer designs and two methods are shown here. In the first I am using clay carbon paper. The second method, using tissue paper, is preferable if you are transferring a design on to a curved or angled surface, as this is forgiving and will slip into any corners and follow the lines of rounded surfaces with ease.

Clay carbon paper

Use this paper when transferring the design on to a flat, or slightly curved surface, like the vase below. Before you start, make sure you are working on the right side of the paper. Do a test: place it on the bisque surface, then make a small mark with a pencil. If the blue mark is transferred on to the bisque, you can continue. If not, turn the carbon paper over, then continue.

Designs can be printed on to the right side of the clay carbon paper using a photocopier and transferred as below: just follow the outlines with a ballpoint as shown. Alternatively, you can sandwich the clay carbon paper between your design and the bisque surface and follow the steps below. The outlines will burn off during the firing process.

See page 28 for this fuchsia design.

1. *You will need clay carbon paper, a red ballpoint pen and a photocopy of your design. Cut around the image leaving enough space to enable you to secure it to the bisque surface, then cut the carbon paper to the same size.*

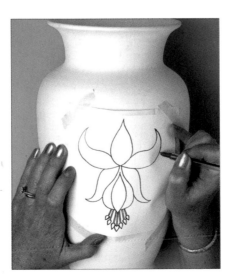

2. *Decide where you want your design and secure both papers firmly to the vase surface using masking tape. Follow the lines of the design carefully using a red ballpoint pen and the image will be transferred on to the bisque surface.*

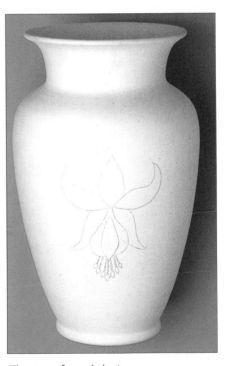

The transferred design.

Tissue paper

Use this method when transferring the design on to a more curved or angled surface, or if you are working on unfired glaze. Make sure that your bisque surface is clean and that the tissue paper is acid-free and absorbent to allow the permanent marker to bleed through on to the bisque.

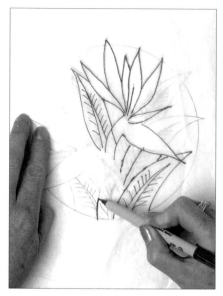

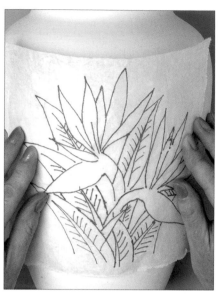

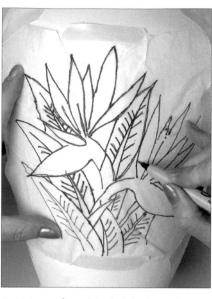

1. Lay the tissue paper on top of the design and trace over the outlines with a fine red felt-tipped pen. At this stage you can adapt or change the design if you wish, simply by adding or omitting lines.

2. When the design is complete, turn the tissue paper over and secure it on to the surface of the bisque using masking tape. Make sure that the vase is firmly fixed in position before starting the next stage.

3. Using a fine, black felt-tipped pen, draw over the red lines, following the outline of the design carefully. In this way, the image will be transferred on to the surface of the vase.

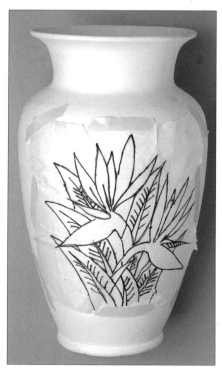

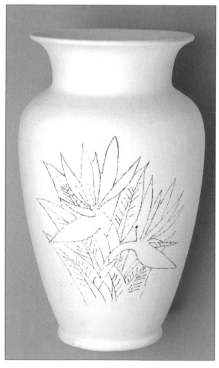

4. When you have finished, make sure that you have traced over all the lines. You are now ready to remove the tissue paper.

The transferred design. Now you are ready to start applying the colours.

This design (see page 22) is an illustration of the beautiful South African Traveller's Tree (Strelitziaceae), which is found in the tropics. It known by this name because travellers would drink from its hollow leaves to quench their thirst. Another name for it is the Bird of Paradise as it so resembles the head of that bird.

Painting a design

We only show a few simple brush strokes and techniques here, but as you gain confidence you can start experimenting with different methods of applying colour. The paints used are one-stroke colours. There are no real rules: relax and have fun.

Simple brushstrokes

Here, the brush is double-loaded and the colours are pulled into a teardrop shape. A No. 6 round sable is used because it holds a lot of paint and it tapers into a good point. Before you start, add undiluted yellow and red paints to a palette as shown.

You will need

One-stroke paints: yellow, red, light green, dark green, soft orange, light purple, dark purple

Brush: round sable No. 6,

1. *Slide your brush through the yellow; blend this colour into the brush on a tile so the yellow is not overloaded. Now gently pull the brush through the red so that it picks up some of the colour on one side. Repeat the technique on the tile so the two colours are nicely blended.*

2. *Practise this on a piece of paper first. Press, pull and lift the brush: push the brush down on to the paper and pull towards you, lifting it as you do so.*

3. *To create the point, twist the brush slightly as it leaves the bisque. The yellow and red mingle to create a shaded effect. Practise this until you feel confident.*

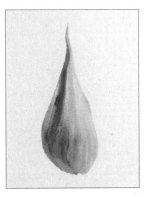

4. *The finished stroke. When you feel confident, it is time to start working on the bisque surface.*

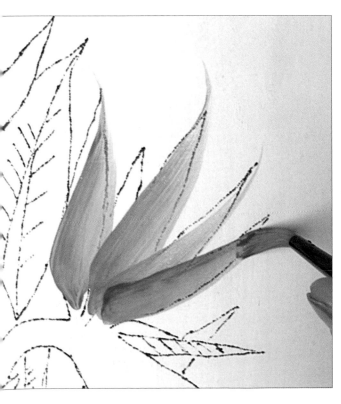

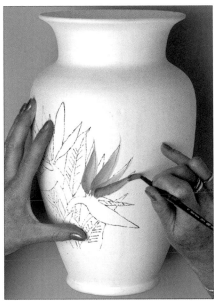

5. *With the No. 6 brush and using the same colours and brushstrokes as above, paint in the petals. Remember: press, pull and lift.*

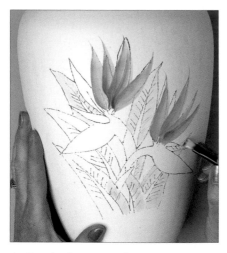

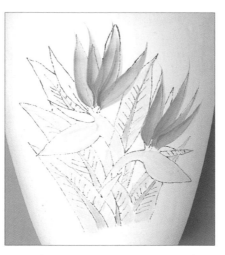

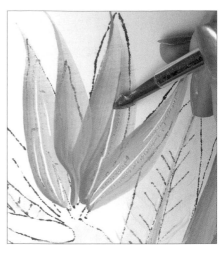

6. For the leaves and trumpets beneath the flowers, dampen a 10mm (⅜in) square shader brush and load it with green. Pull the colour out from the central leaf veins on each side. Pull in lighter green and blend the colours across each other.

7. At this stage, you can paint in the central veins using a soft orange and a No. 4 round brush. The colour should have the consistency of ink, so add a little water as necessary.

8. Highlights are added using a sgraffito tool: scratch lines through the paint, following the curved shape of the petals, tapering them off near the top of the flower.

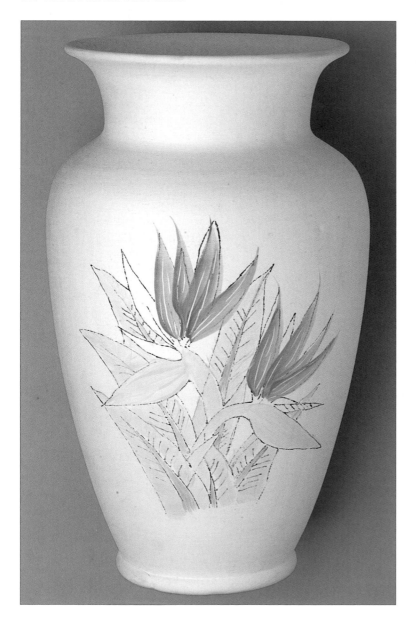

9. I have now finished adding the basic colours here. Light and dark purple and darker tones of green can now be added, and the final petals and leaves painted in.

Tip
If the colours are too dry, they can be misted with a water spray to dampen them.

Opposite
The finished vase
Green bands are added with a No. 3 round brush and a banding wheel.

More colour is added to the flowers and leaves. To create the feathered look on the leaves, very dry dark green is dragged over the lighter green using a No. 6 brush. More leaf and flower veins are scratched out of some of the still slightly wet petals.

Touches of orange are pulled through the trumpets beneath the flowers and some of the petals are painted using two shades of purple. Shadows are added with a No. 2 soft squirrel brush loaded with diluted black.

The vase is fired once, glazed, then re-fired.

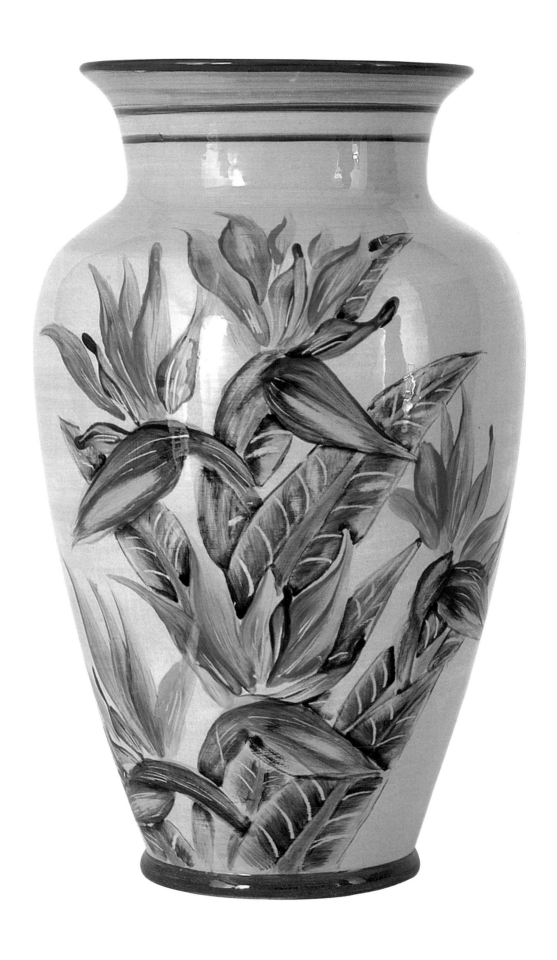

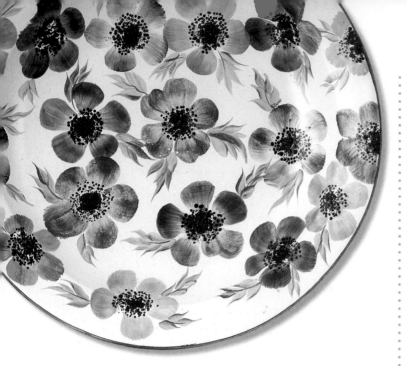

Anemone Bowl

Design: see page 25

This is a Majolica technique, which is the art of applying underglaze colour on top of an unfired glaze. The bowl is painted with a white matt glaze, then one-stroke colours are applied using simple brushstrokes.

First, the bowl is painted with two coats of matt glaze.

When dry, the design is transferred using the tissue paper method (see page 8).

All the colours are diluted seventy per cent colour to thirty per cent water. This is because when using the Majolica technique, the paint needs thinning, or blistering will occur.

Four colours are used for the flowers and each one is applied with two shades of the same colour family; for example light and dark blue, light and dark pink and so on. All the flowers are painted on with a No. 12 round sable brush.

The brush is loaded with the lighter of the two colours (see page 9) and tipped with the darker shade. The press, pull and lift stroke is used for the petals, working towards the flower centres.

When all the flowers have been completed, the centres are sponged with diluted black. When dry, the stamens are added with the wooden end of the brush loaded with diluted black.

A 10/0 liner brush is loaded with diluted dark green one-stroke. Some stems are pulled out from the sides of the flowers. The leaves are applied with a No. 4 round brush. This is loaded with light green and tipped with dark green. Five leaves are pulled off the stem using press, lift and pull strokes.

When the bowl is dry, a black band is applied with a banding sponge. As the bowl has already been glazed, there is no need to add a top coat before firing.

Farmyard Plate

Design: see pages 44 and 45

What a great plate for a Welsh dresser. Try your hand at this simple brushwork in bright coloured one-stroke. The design is transferred using the carbon paper method (see page 7).

First, a blue band is applied to the edge of the plate with a banding sponge.

All the colours are placed on to a glazed tile and thinned a little with water. The flower combinations vary: yellow is tipped with orange, light blue is tipped with dark blue, light pink is tipped with dark pink and so on.

The larger flowers are all painted on with the C stroke: load a 10mm (³⁄₈in) angled square shader with light blue, and side load it on the longer side with dark blue. Visualise a clock face; the short side of the shader is placed at six o' clock and does not move, while the longer side with the darker shade moves from nine to three o' clock (three to nine o' clock if you are left-handed). This brushstroke creates one petal. Repeat five times for each flower.

The smaller flowers are applied with a No. 3 round brush and the press, pull and lift stroke (see page 9).

All the centres are filled in with perfect circles using the wooden end of the brush dipped in complementary colours.

The hen is painted on with a wash of seventy per cent water to thirty per cent brown; this should be very pale and transparent.

The tail feathers are added by loading a No. 3 round brush with different colours, one at a time. Using the press, pull and lift stroke, the feathers are painted in and lifted off to a point. The brush is pulled in different directions to make the tail look more realistic. Some small feathers are added to the hen's body in the same way.

The red details around the hen's face are filled in and the eye is placed in with the wooden end of a 10/0 liner brush. Part of the image is then outlined with the liner and diluted black.

The paints are fired in to set the colours before the plate is clear-glazed and fired again.

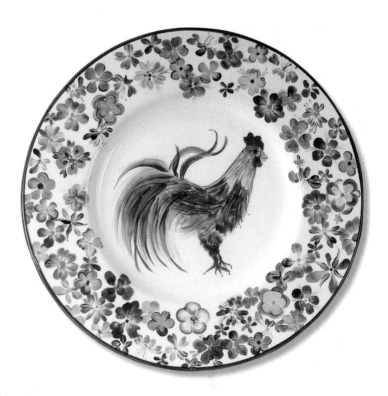

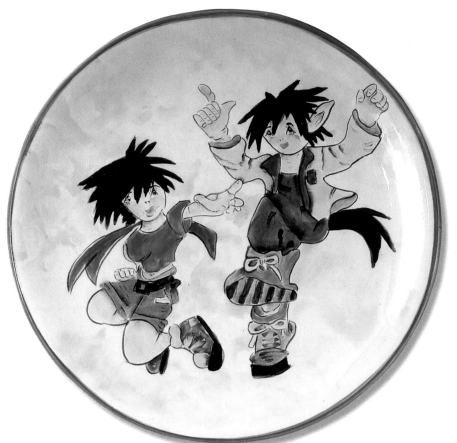

Manga Plate

Design: see pages 55 and 56

This plate is painted using glaze-based underglaze colours and it has a wash-style background.

The designs are transferred using the carbon paper method (see page 7).

The background colour is applied with a soft 1cm (½in) round goat hair brush. Yellow is thinned, seventy per cent water to colour, and it is stippled on to create a soft marbled effect.

The rest of the colours are applied three times using soft round sable brushes Nos. 3 and 6.

The eyes and small details are completed with a No.1 liner brush with slightly diluted colours.

The plate is banded with a banding sponge loaded with red.

When completely dry, the plate is dipped in clear glaze and fired.

Cherry Plate

Design: see page 31

This dinner plate is painted using glaze-based underglaze colours.

A banding wheel is used to create the outer bands of colour. Each one is thinned fifty per cent water to paint and applied with a No. 8 fan brush. The thinner lines are applied with a No. 1 sable liner brush.

The design is transferred using the tissue paper method (see page 8).

Each of the cherries is pounced on to the plate twice with a small sponge on a stick. The colour is allowed to dry between applications, so that the red becomes more solid.

Between the cherries, a thin wavy stem is painted in dark green using the liner brush.

To apply the leaves around the cherries, a No. 4 round sable brush is used. This is loaded with light green and then the brush is pulled through dark green. Leaves are painted up and down the stem between the cherries, using the press, pull and lift stroke (see page 9).

After the plate is dry, it is dip-glazed and fired.

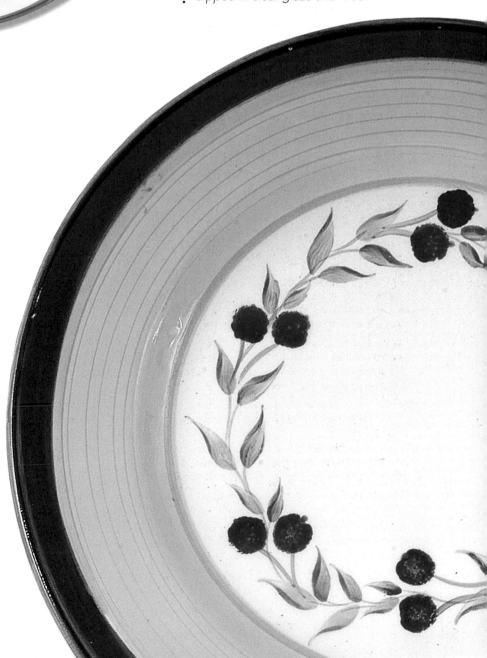

Christmas Celebration

Designs: pages 75 and 77

This festive cake stand could be used to display biscuits or cakes.

The designs are transferred using the tissue paper method (see page 8).

The whole design is painted with one-stroke colours.

A red band is applied to the base and rim of the plate using a banding sponge.

The holly leaf border design is applied using a 10mm (³⁄₈in) square shader. This is loaded with light green, then the brush is pulled through dark green and blended a little on a glazed tile before the strokes are worked. The C stroke is used from the stems to the tip of the leaves (see Farmyard Plate on page 12).

The berries are applied with a cotton wool bud.

The rest of the plate is painted using round sables Nos. 3 and 6, as these natural brushes hold more paint. The colours are thinned with water in places, to give a watercolour effect.

All the tree foliage is painted in using three shades of green one-stroke, which is thinned with water and applied with a No. 1 liner brush.

The plate is fired to set the colours and then dipped in clear glaze and refired.

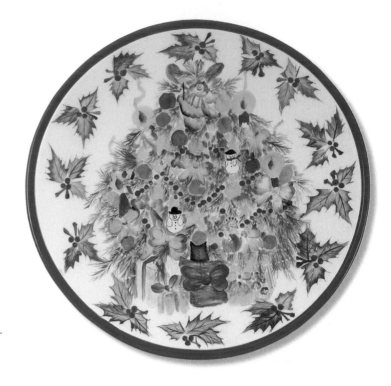

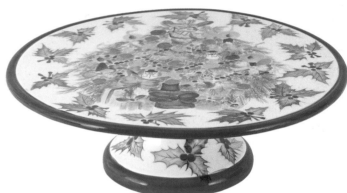

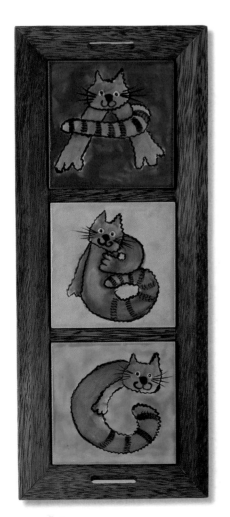

Cats' ABC Tray

Design: see page 81

This useful small tiled tray is ideal for morning coffee, or an afternoon snack. The three tiles are set into the tray after firing.

The letters are transferred using the carbon paper method (see page 7) and painted in using glaze-based underglaze colours before they are outlined in one-stroke black.

Still using the glaze-based underglaze colours, the backgrounds are painted in using a No. 6 round sable brush. Each colour is slightly diluted and then 'patted' in to create the marbled effect.

The cats are painted in with two coats of tan underglaze.

A third colour is introduced by loading a 13mm (½in) square shader with tan and the side of the brush is then pulled through dark brown. This is applied keeping the dark paint on the outside of the cats to create the shadows.

The stripes are applied using one-stroke paints and a No. 1 liner: rows of single hairs pulled in using slightly thinned dark brown. For the eyes, the wooden end of the brush is dipped in white and the paint applied carefully. When dry, a smaller dot of black is added to the top half of the eye, leaving a half moon of white below.

The detail on the cats is applied using a 10/0 liner loaded with black one-stroke thinned fifty per cent water and fifty per cent colour.

Two coats of brush-on glaze are applied with a No. 8 fan brush.

The tiles are then fired.

Elephant Plate

Design: see page 69

This plate is painted using one-stroke colours and a raised glaze. The design is transferred using the carbon paper method (see page 7).

A thin wash of grey is applied with a No. 4 round sable brush to create a watercolour effect.

All the colours on the coat and decorative bands are then painted in with No. 4 and No. 6 round sable brushes.

The eyes are detailed in blue and black using a 10/0 liner brush.

To complete the project, a fairly thick yellow band is applied around the edge of the plate with a banding sponge. Another thinner green band is applied on the outer edge partly overlapping the yellow.

Small dots are applied all round the plate using a raised green glaze

A 10/0 liner brush, loaded with slightly diluted grey, is used to outline the central design.

When dry, the plate is fired to set the colour. It is then clear-glazed and refired.

Gold detailing is applied on top of the glaze and the plate is then fired for the third time.

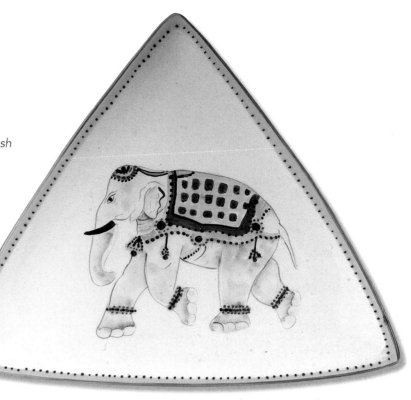

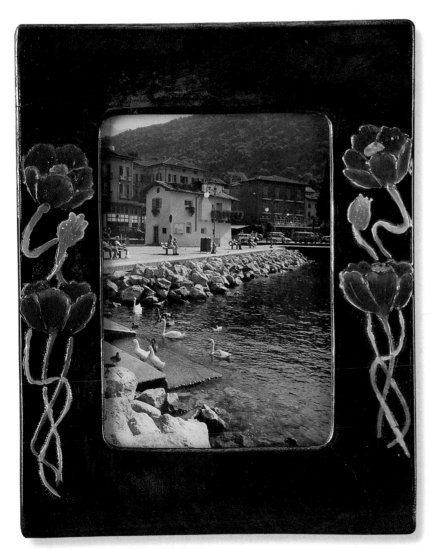

Poppy Frame

Design: see page 35

This is an easy way to cover solid colour with a design, and a three dimensional effect is created with the piping paste. The poppies are painted using glaze-based underglaze colours.

Three smooth coats of black underglaze are applied with a soft No. 8 fan brush.

When the paint is dry, the design is cut to size, placed on one side of the frame and a cocktail stick is used to outline the images. The same design is then reversed and applied to the opposite side of the frame.

The poppies are filled in using a No. 3 round brush loaded with white clay piping paste. This is opaque, so it covers the black base coat.

The design is then painted with reds and greens, using the No. 3 round brush.

When dry, one coat of brush-on glaze is applied and the frame is then fired.

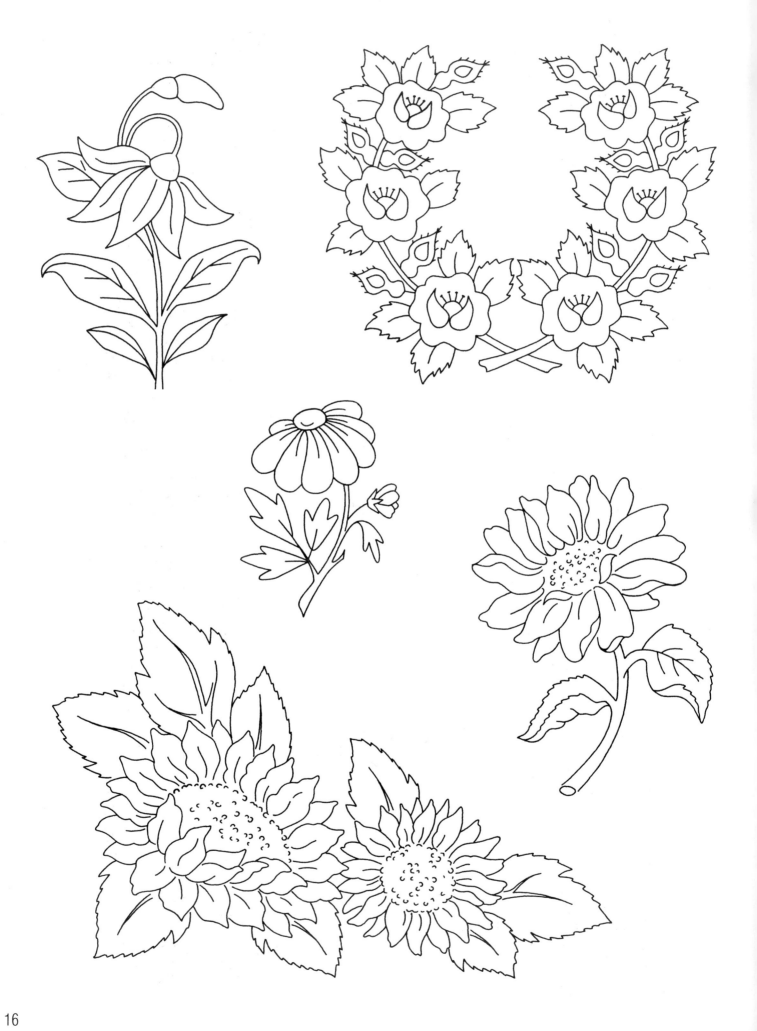

16

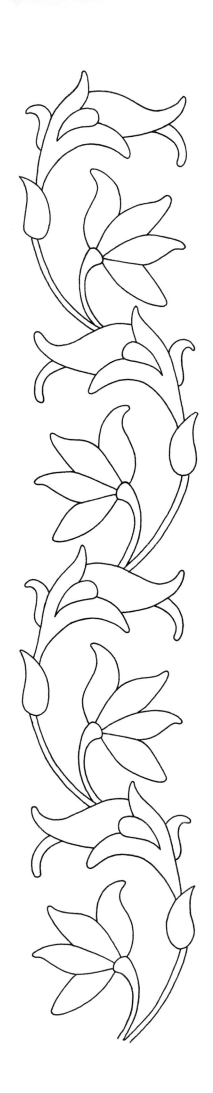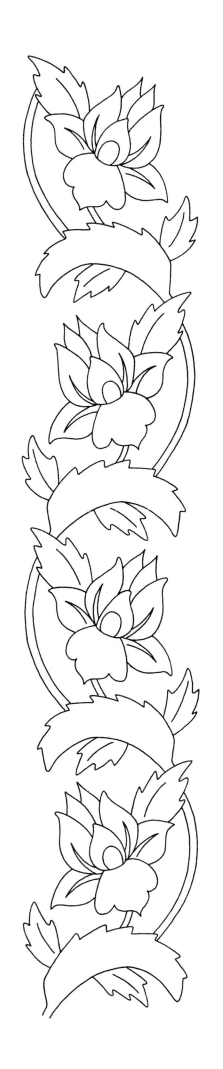

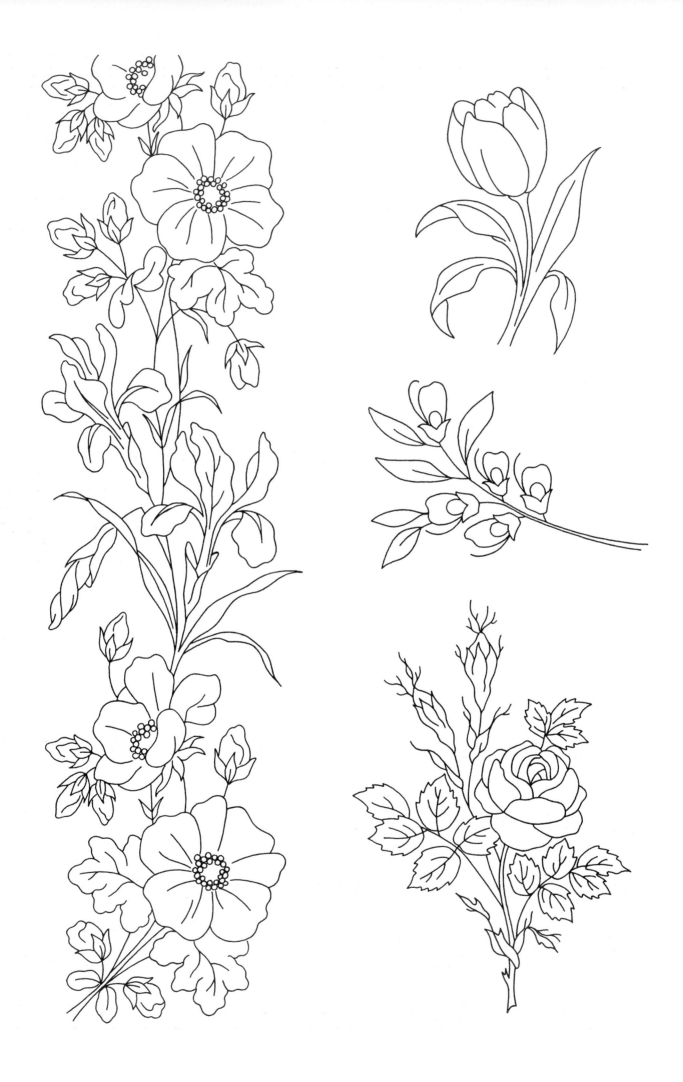

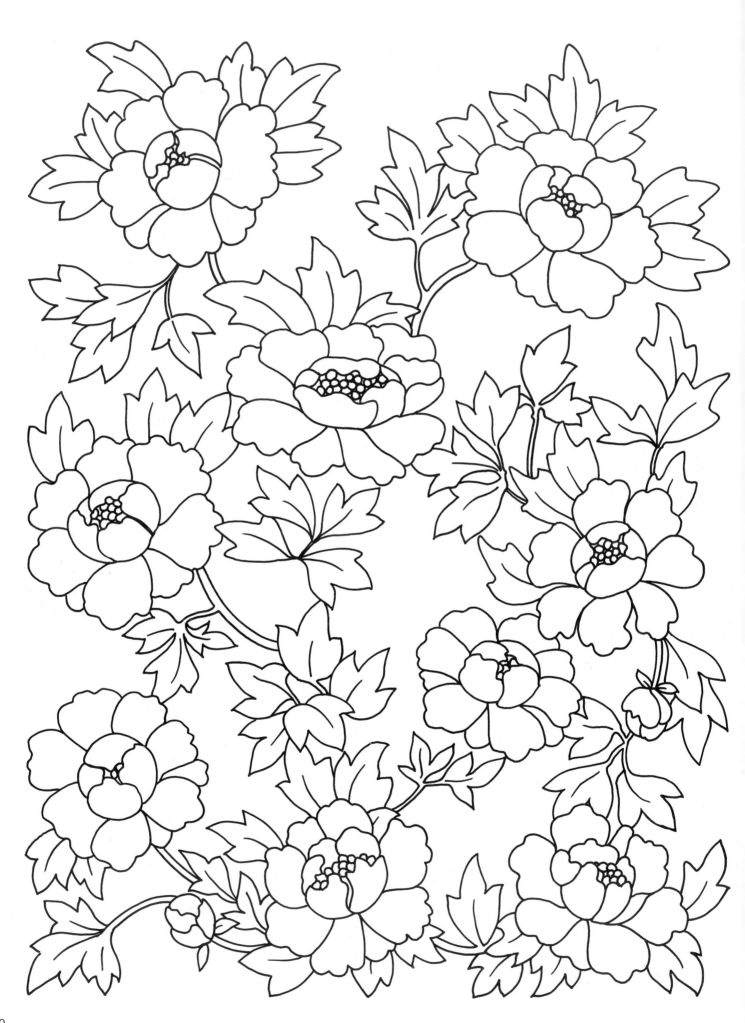

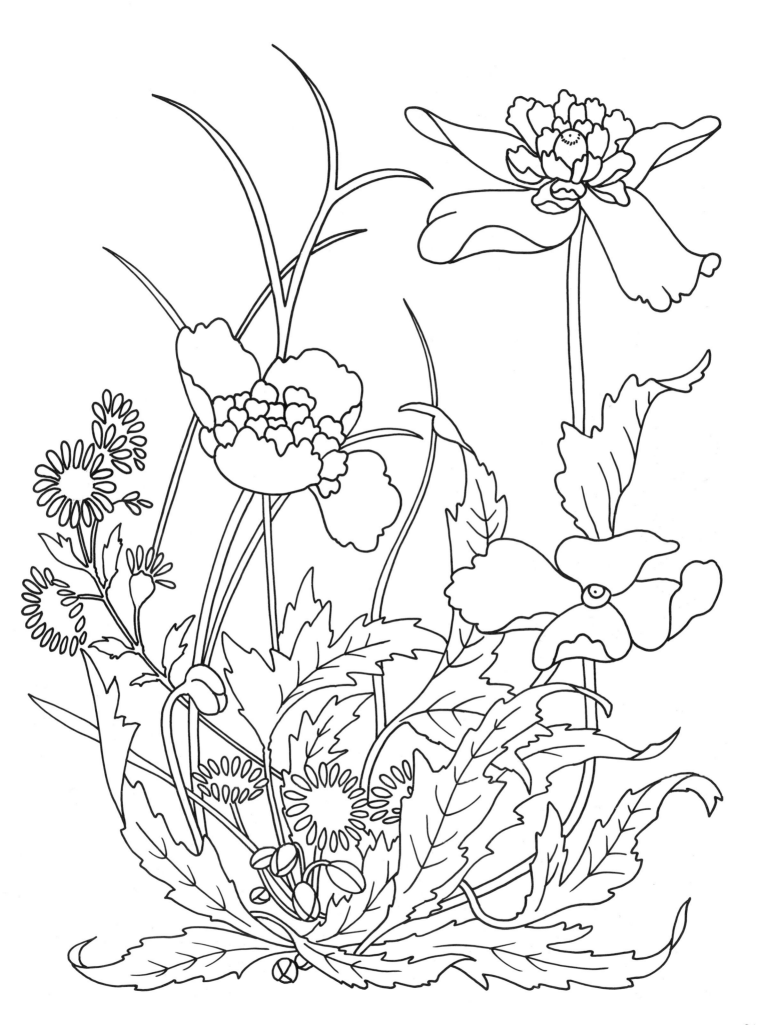

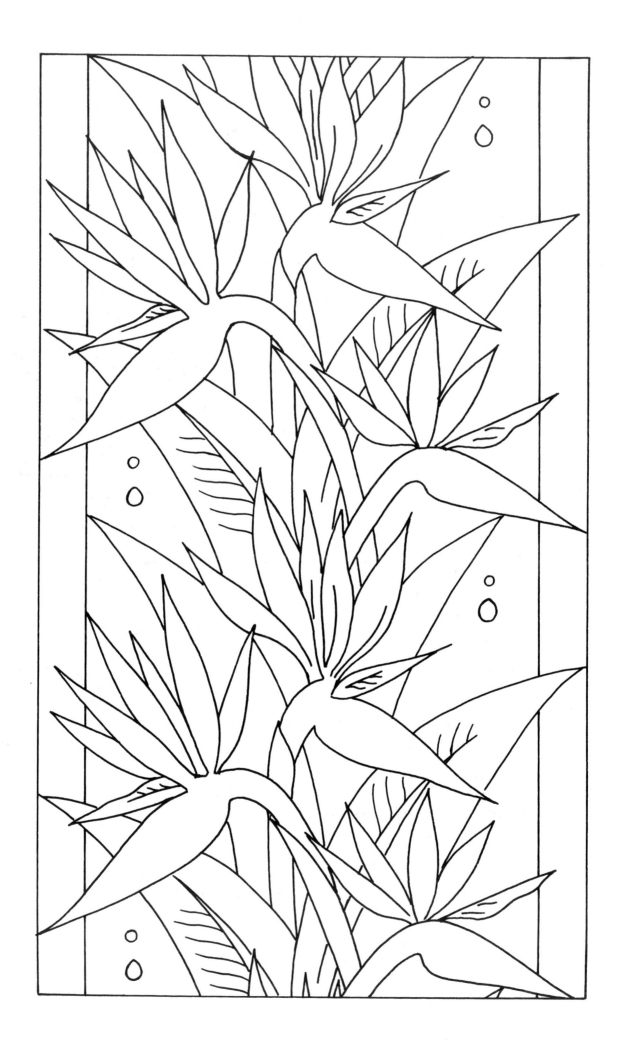

22

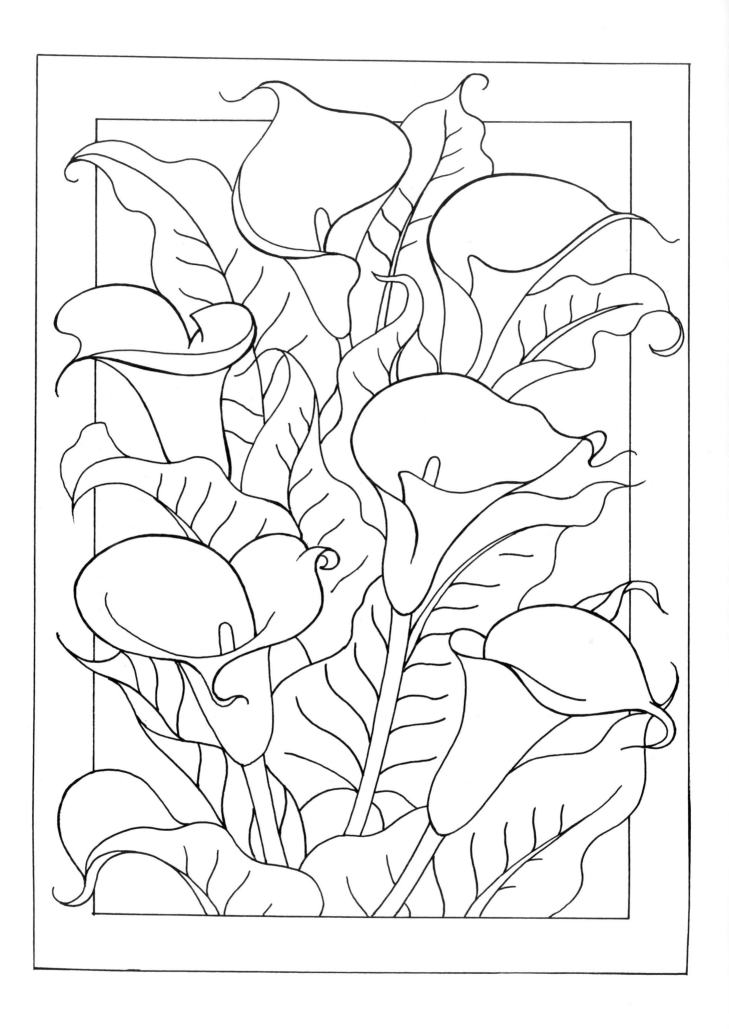

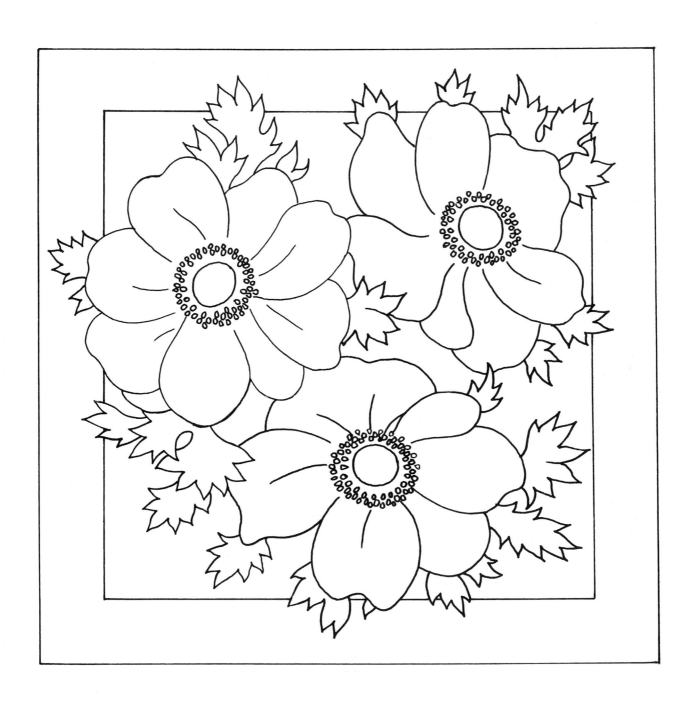

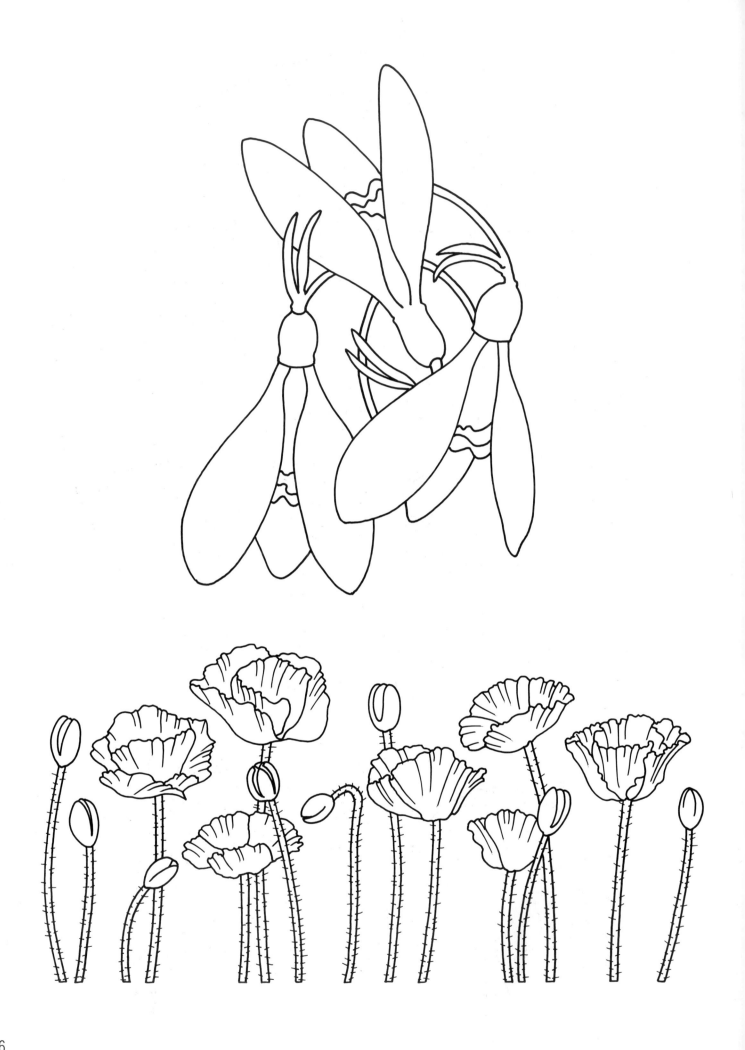

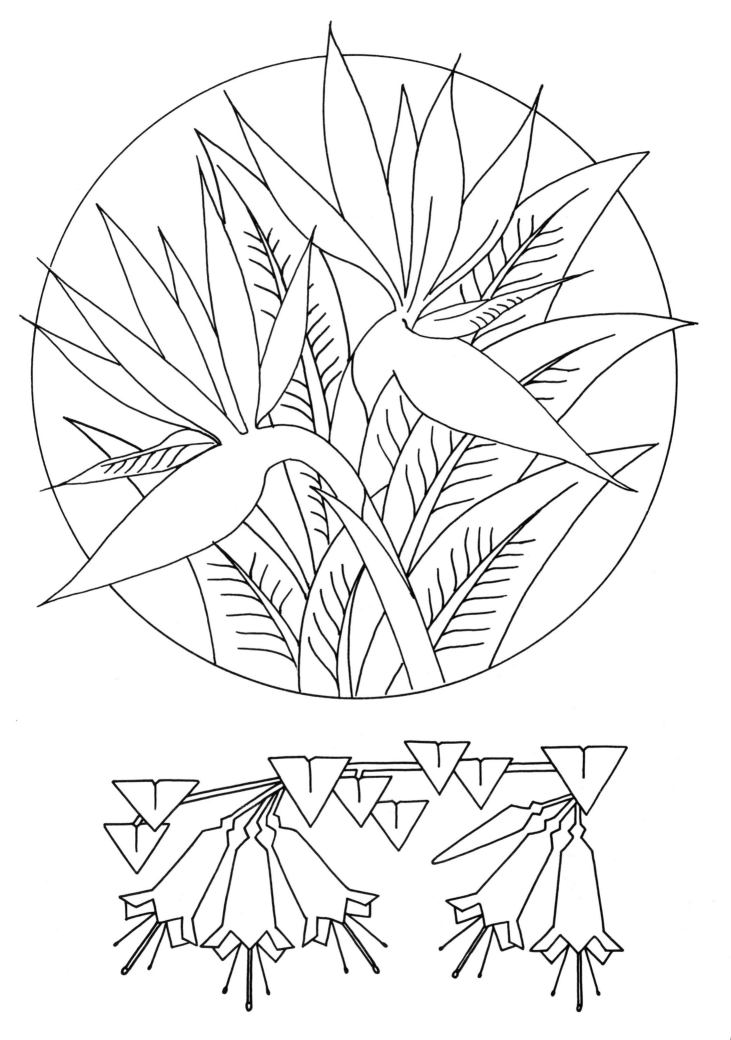

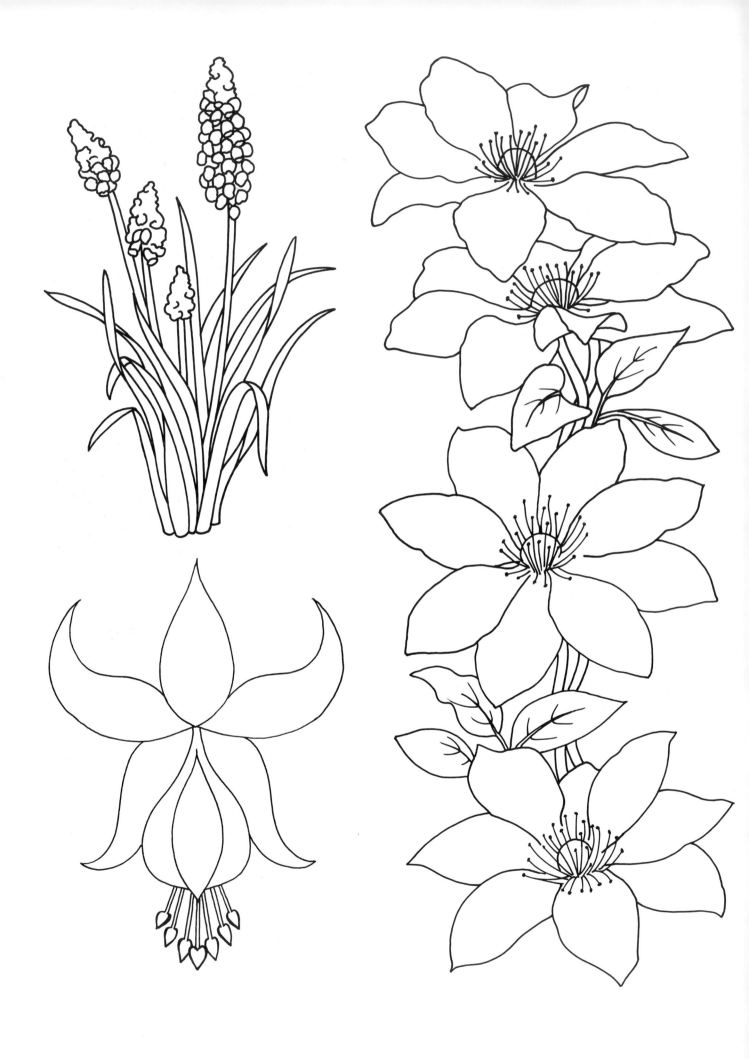

34

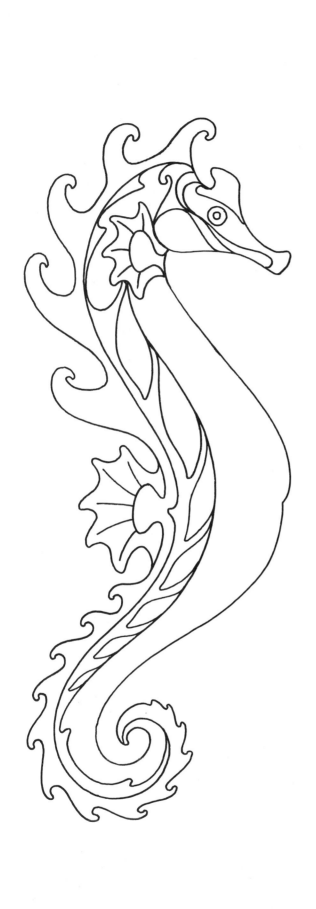

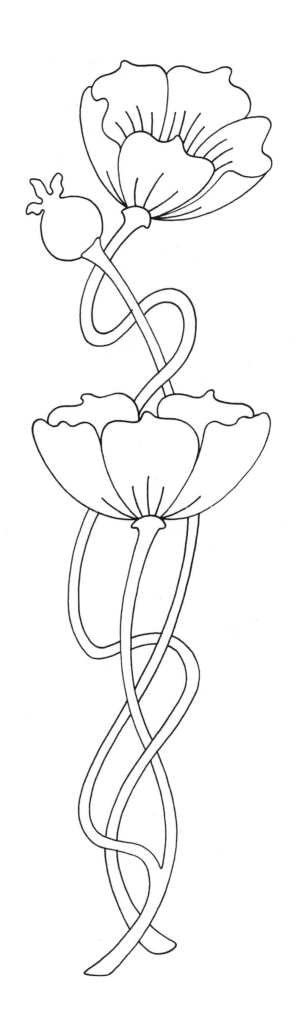

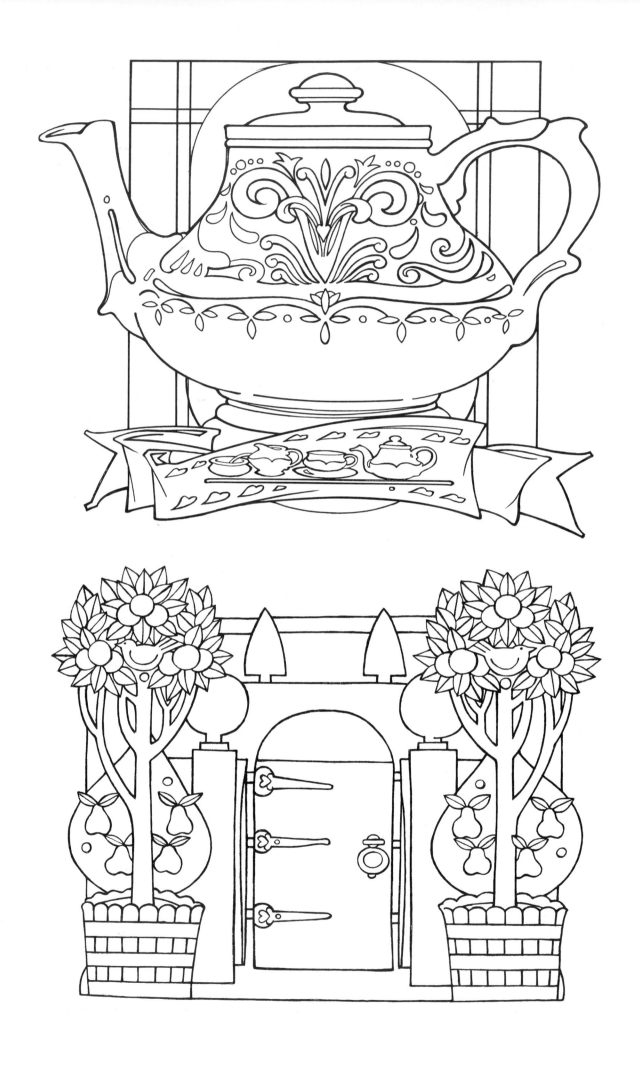

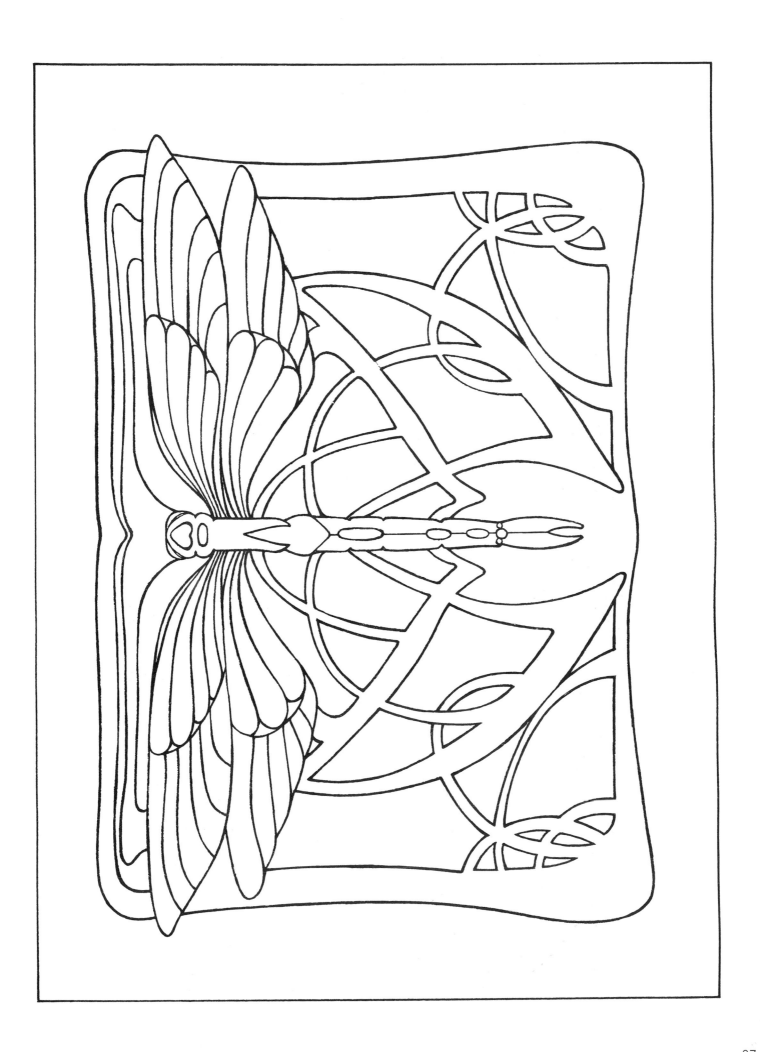

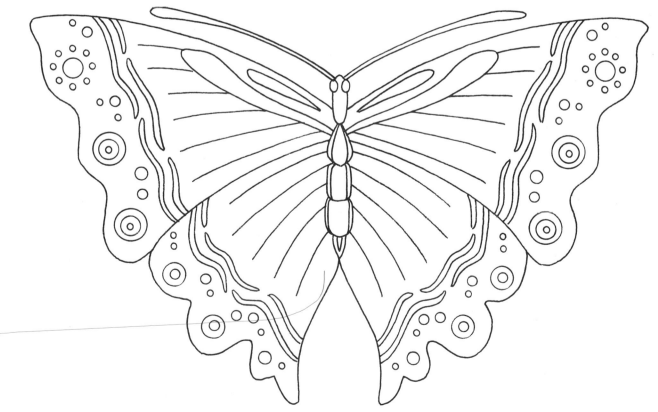

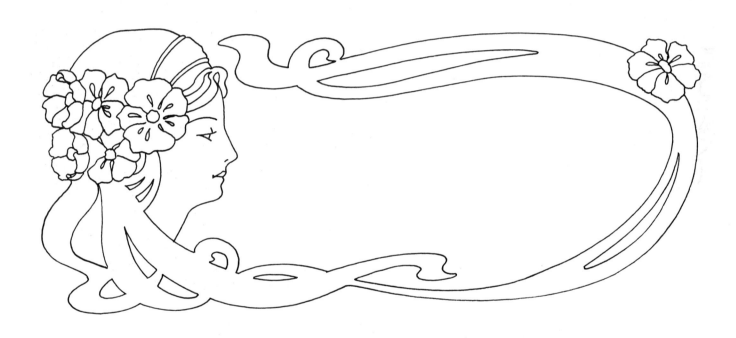

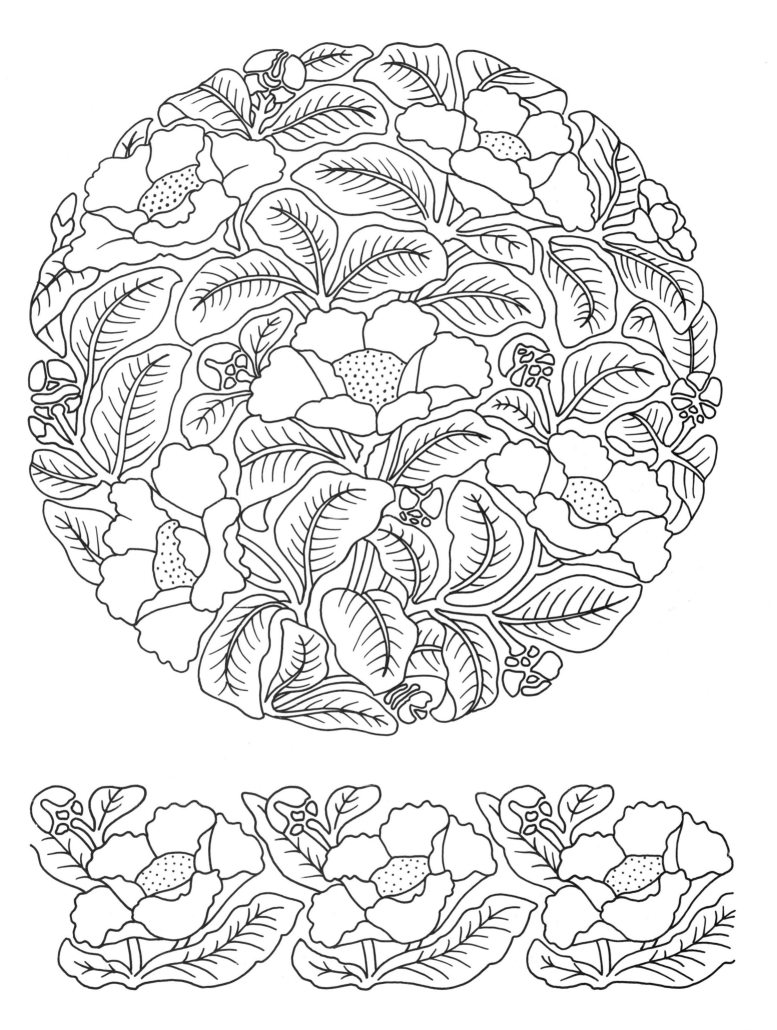

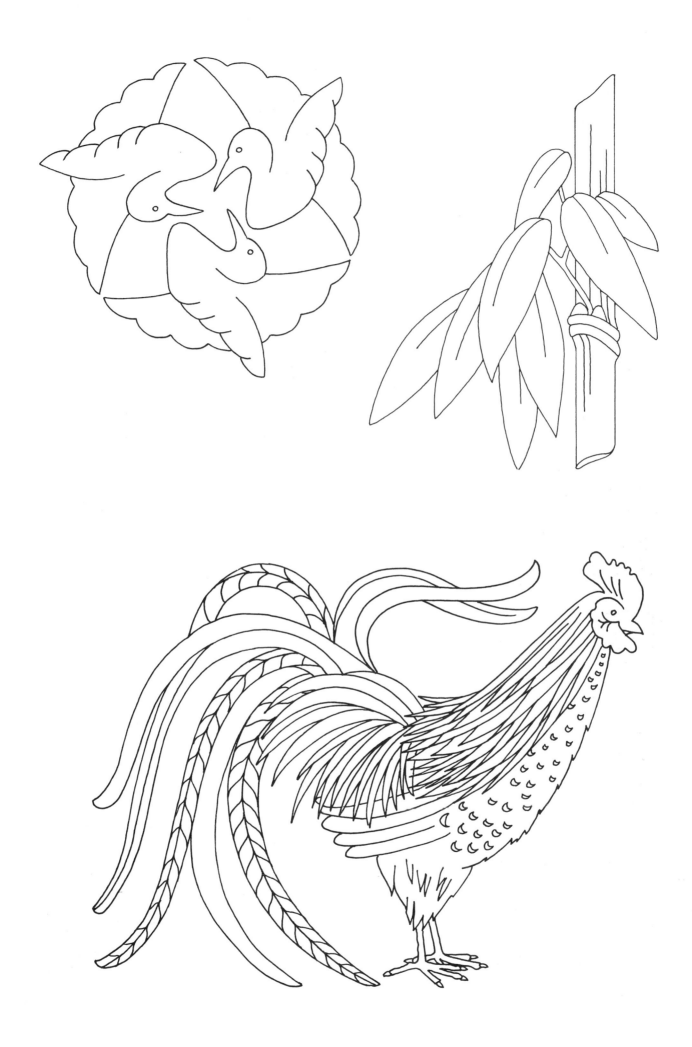

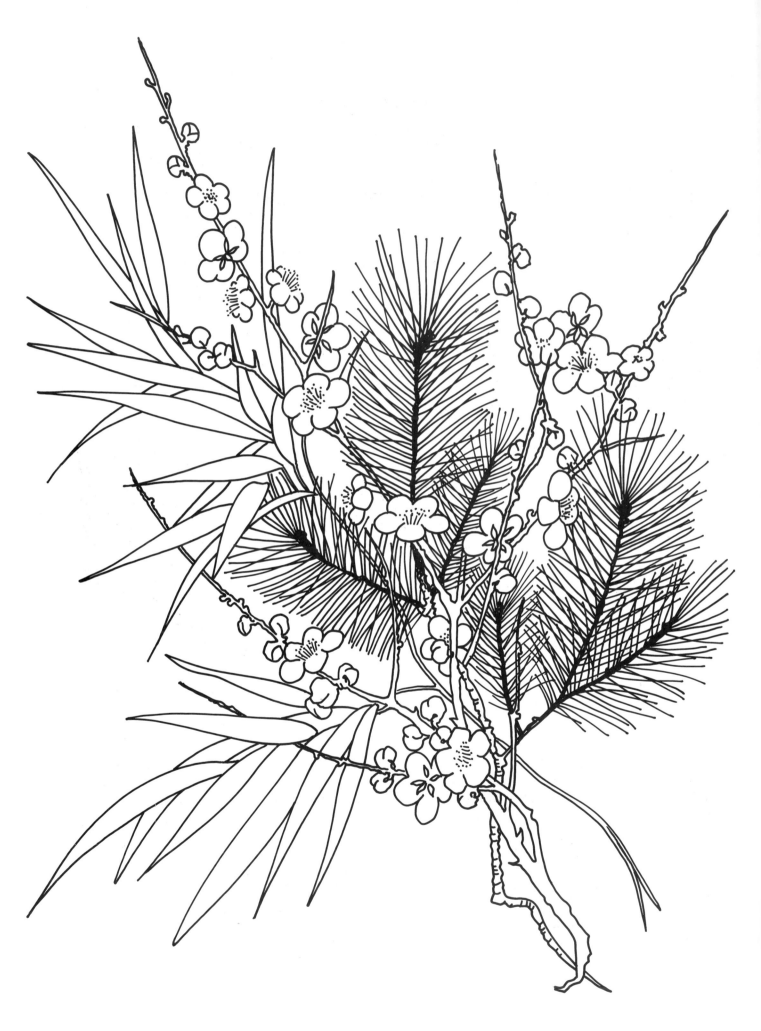

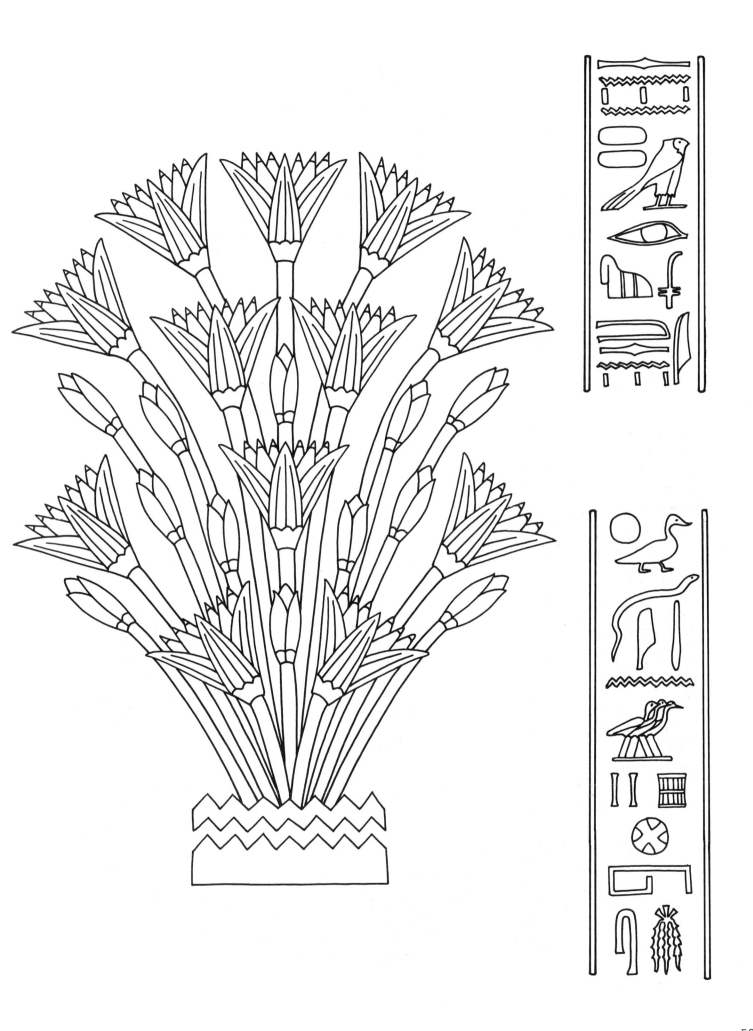

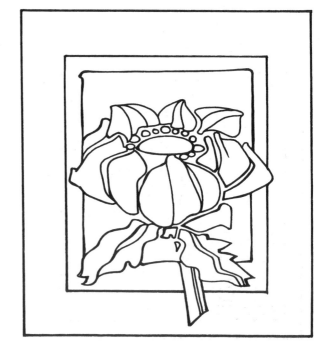

63

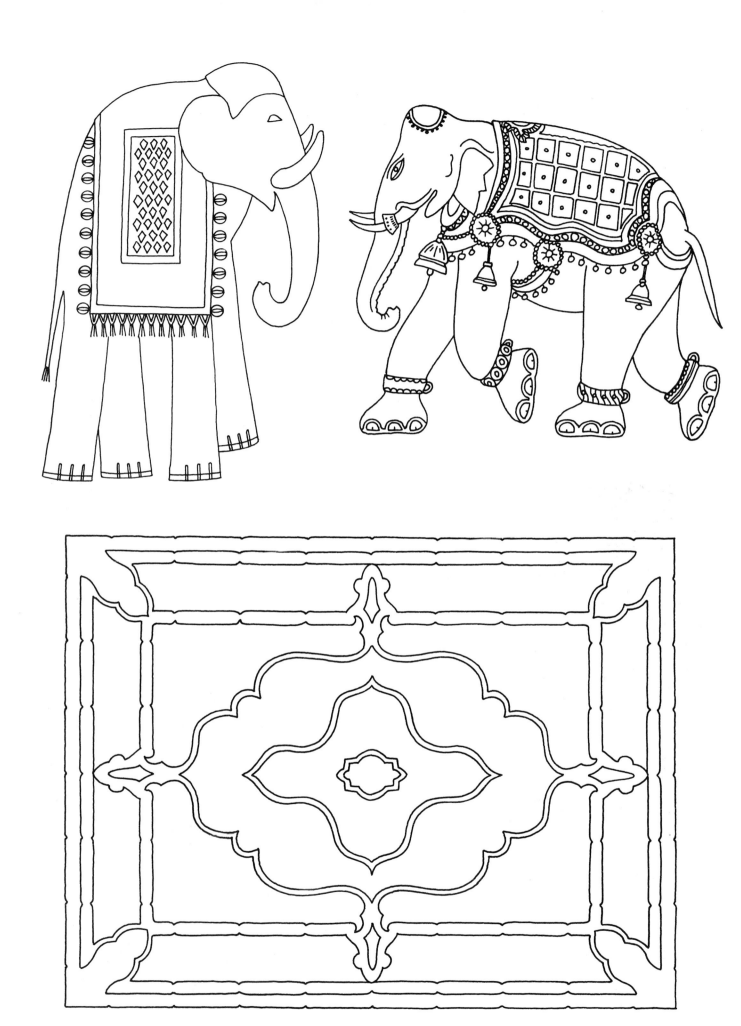

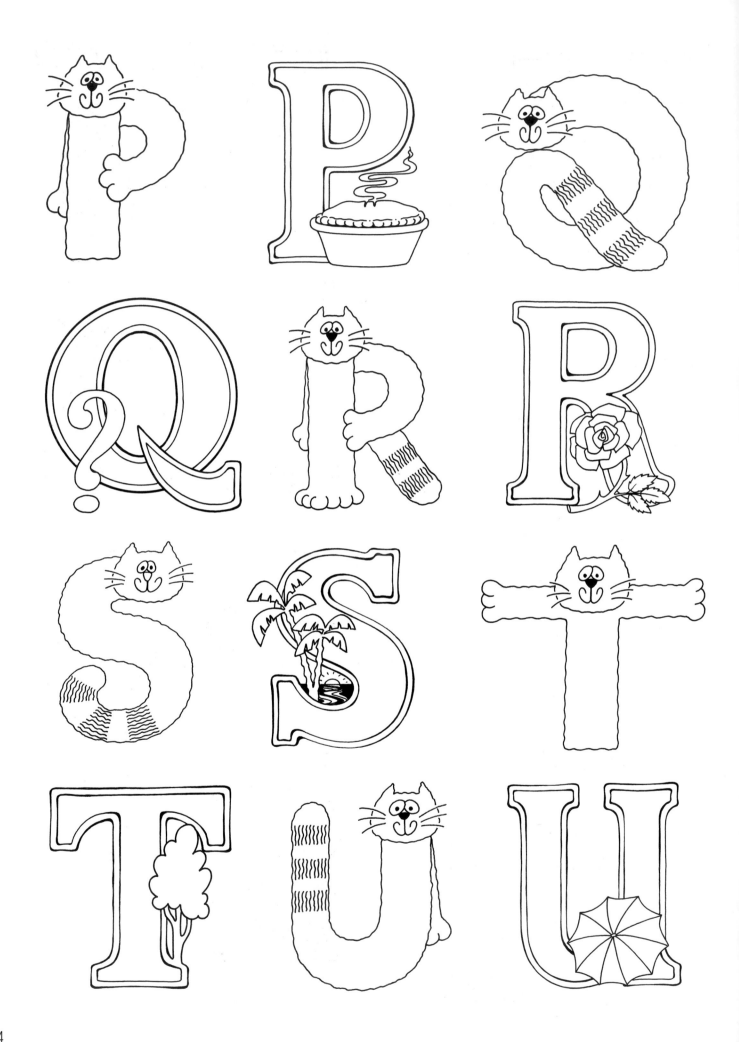

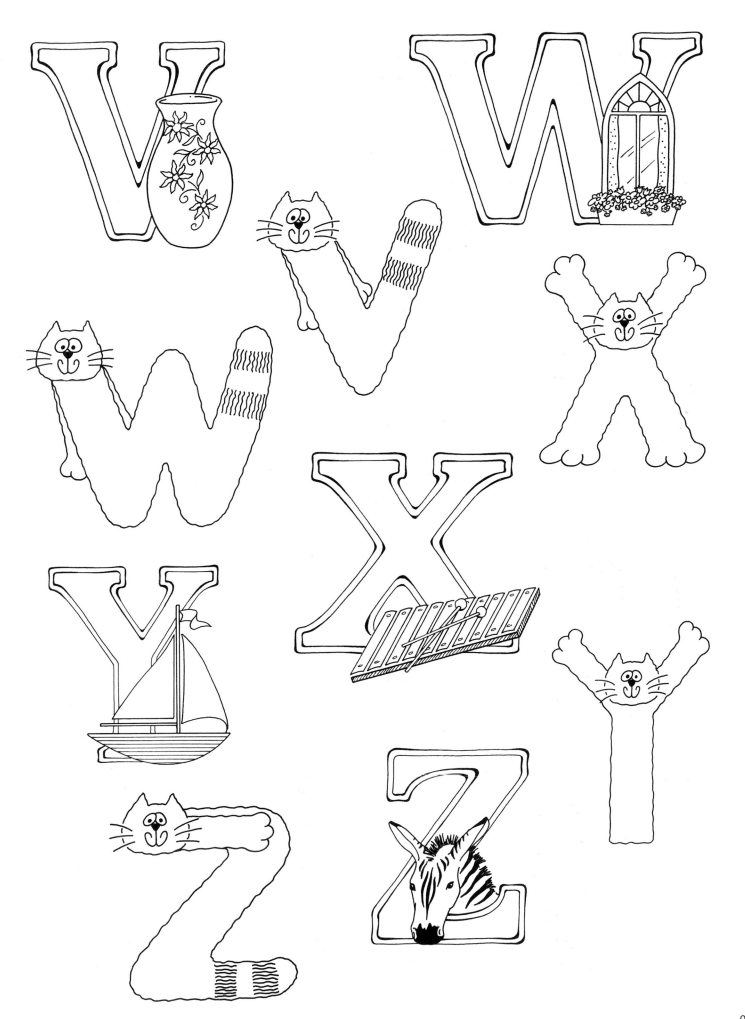

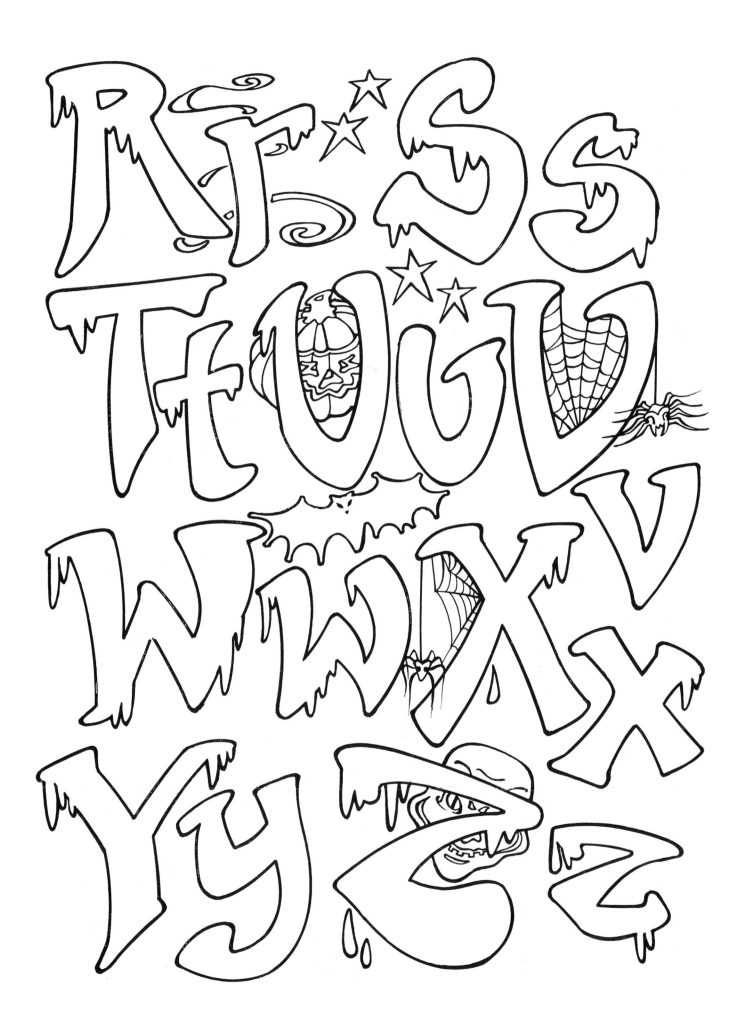

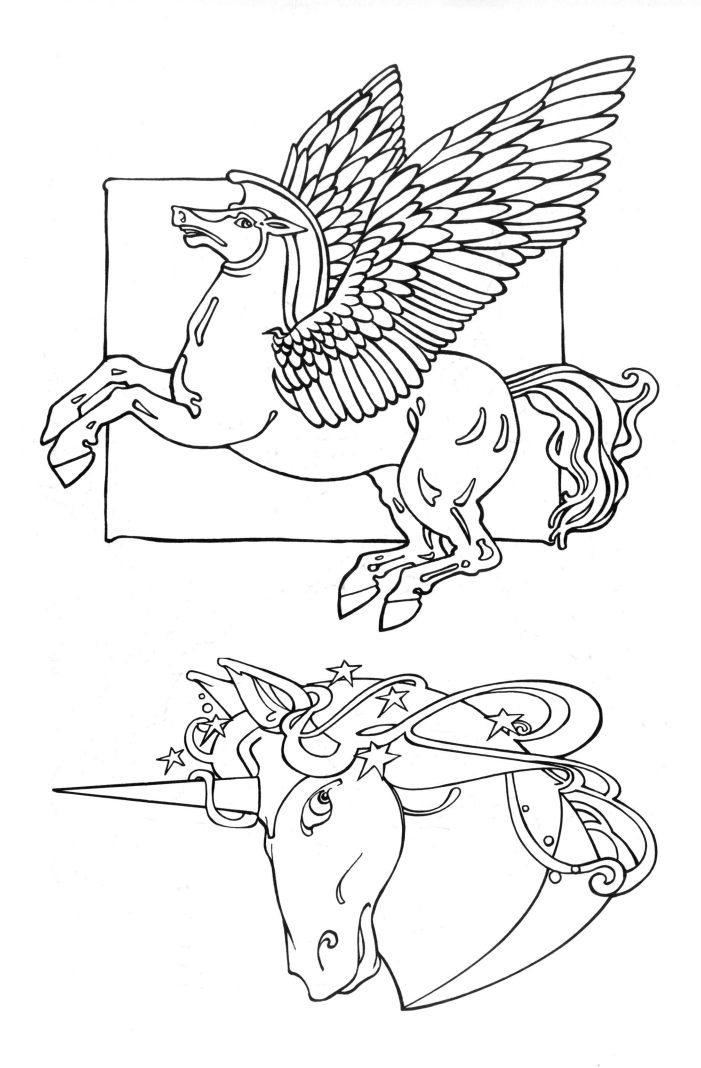

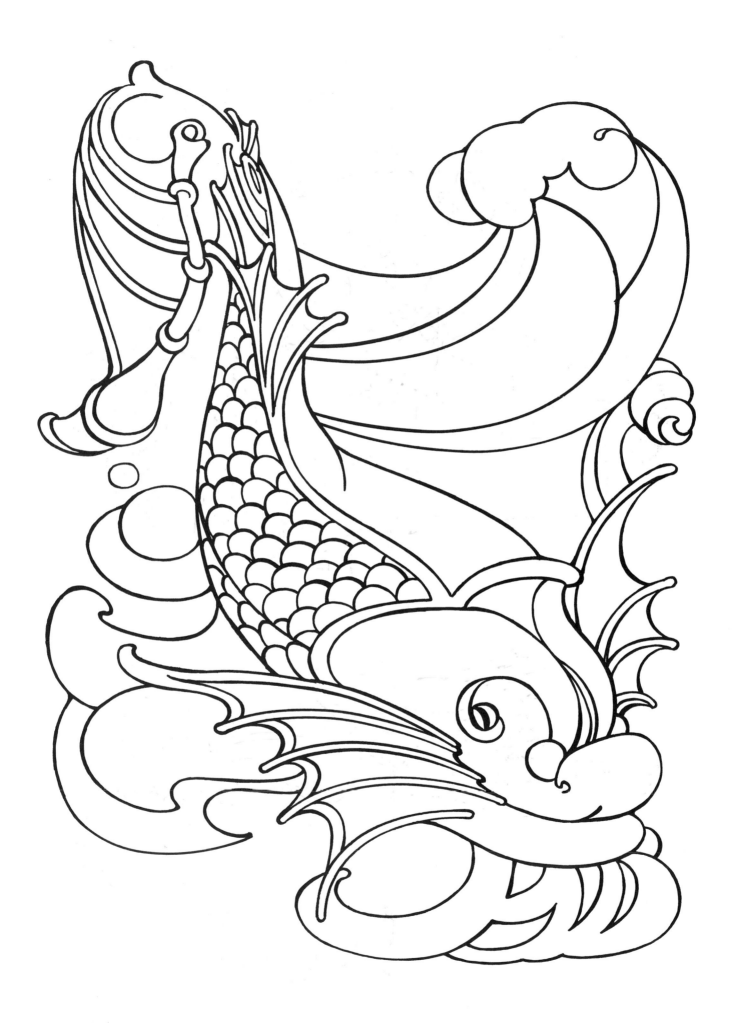

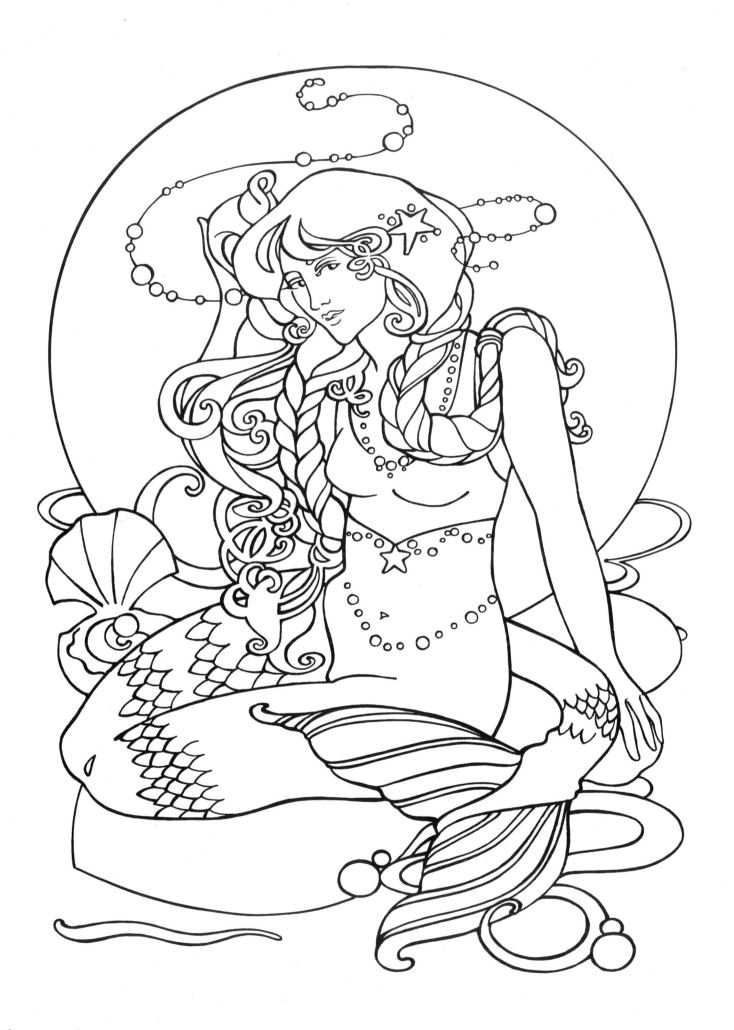